NYC RESTAURANT ADS

1981-1998

PUBLIC IMAGE LIBRARY

Edited by Nikki Igol

Eat to the Beat

"Odeon not only homesteaded TriBeCa but announced that downtown had grown up enough to have a plutocracy all its own." -Gael Greene, *New York Magazine*, January 15, 1996

Appearing in a 1981 issue of *Interview Magazine*, an advertisement for the restaurant **1/5**, located at One Fifth Avenue, typified an emerging era of New York fine dining, one of hipped-in ads and experimental graphic design. The adverts for 1/5 were minimal to the max - a simple black and white illustration: the fraction which also cryptically described it's location on the Manhattan street matrix; the only other clue given is an abreviated phone number for reservations. Downtown spoke with an inside-voice: a reader unversed in New York at that moment would be lost, unsure what, if anything, the ad was meant to communicate.

Downtown New York in the early 1980s was emerging from a long spell of austere conceptualism, brought about by movements in both the high-brow theory of contemporary art and the low-down facts of municipal economics. Swaths of downtown were blighted by poverty, drugs, crime, but also teeming with a new culture germinated in the empty spaces vacated by former factories and warehouses; artists lofts, loft parties, a whole provo-scene (romantically, and somewhat belatedly, portrayed in Martin Scorsese's 1985 film *After Hours*). At the center of the real-life SoHo art scene was the artist-run restaurant **FOOD**, founded by Carol Goodden, Tina Girouard, and Gordan Matta-Clark. The now-legendary meals included happenings such as Matta-Bones, a soup by Matta-Clark that returned the stock-bones to the diner as a necklace.

During this period, the advertising in Andy Warhol's *Interview* magazine was dominated by ad spots for records, hifi equipment, and gallery openings. A typical issue proclaimed new releases by Patti Labelle, Lou Reed, Grace Jones; audiophile turntable tonearms; openings at Castelli Gallery. By evidence of the ads, the ideal *Interview* reader shopped at little boutiques, attended SoHo art gallery openings, munched at **Spring Street Natural**, bought records, bought more records, and danced nightly at Trude Heller, The Loft, Le Jardin (and a few years later, Studio 54). But during the early 1980s the magazine advertising scope began to widen and diversify, tracking downtown's growing affluence: the ads shifted to luxury: limo service to the Hamptons, European fashion labels, top shelf liquors.

In this evolving consumer context, the highly conceptual but also cooly exclusive 1/5 ads express the shifting cultural sands. Founded by Austrian emigres George Schwarz and Kiki Kogelnik, 1/5 was Schwarz's second restaurant in New York. An oncologist by training, Schwarz's first spot, Greenwich Village's **Elephant & Castle**, was an early American-bistro and coffee bar that anticipated a trend for intentionally sourced ingredients and coffee-culture. George Schwarz procured carefully chosen cheeses and breads, and his artist wife Kiki Kogelnik delivered design and concept, including a simple and charming illustration still in use today.

After Elephant & Castle, 1/5th was a far more ambitious project. Located on the ground floor of the iconic Washington Square art deco tower at the base of Fifth Avene, 1/5 took the building's original nautical theme and propelled it further out to sea. George and Kiki decorated the bar with fittings bought from the RMS Caronia at a salvage sale held on Pier 54 before that once venerable Cunard cruiser was sold for scrap. Soon after, when the ship sunk near Guam enroute to a Taiwan breaking-yard, Kiki designed a postcard for the restaurant showing the capsized wreck with the caption, "You are invited". The image evokes a film-noir tinted mood of disaster and despair, but in truth the good times were just about to begin.

George and Kiki went on to purchase the shuttered **Keens Steakhouse**, as well as eventually opening both the **NoHo Star** and the **Temple Bar**. They also hired, at 1/5, two British brothers, Keith and Brian McNally, whom, alongside Lynn Wagenknecht, spawned **Odeon** (formerly **Towers Cafeteria**, one of New York's last). And more was to follow: **Café Luxembourg**, **Canal Bar**, **Indochine**, **Pastis**, to name a few of the spots that came to define a certain vision of New York documented by writers such as Jay McInerney, Bret Easton Ellis, and Candace Bushnell.

The explosion of downtown dining is gloriously documented in the advertising pages of downtown's interzone publications, especially *Interview*, *Details*, and *Paper*. Reading the ads

is as fun as reading the actual articles and interviews. For starters, the ads are a reminder that fine dining in New York prior to the 1980s was dominated by French and Italian menus. **Mr. Chow**, imported from London by way of Beverley Hills, began the widening of the pallet. Japanese food, especially sushi, became an Eighties visual glyph for expensive urban sophistication; Michael Douglas and Daryl Hannah make a meal of it in Oliver Stone's 1987 *Wall Street*. Similarly to SoHo's belated paeon After Hours, Gordon Gecko was inevitably a few years behind trend; **Kamon** was amongst Detail's earliest advertisers in 1983, and by 1985 **Nishi Noho** took out full pages of *Interview* to print it's own downtown Page Six of celebrity gossip.

Perhaps less well remembered was that the 1980s brought Mexican food to New York. There was **El Teddy's** (a Tribeca scenester spot, a few blocks up from Odeon), **Bandito's** (uptown spot, tag line: "Everyone Knows it's Mexican Food by now"), and my favorite, **Hi-Techs Mex** (think the old post-modern Taco Bell aesthetic on speed, featuring "hi tech margaritas"). Demographically, the trend was driven not so much by immigration from Mexico and Central America itself (that would happen in the early 90s), but more courtesy of bi-costal LA transplants, nostalgic for high quality west coast comfort food.

The Californians also brought their own neo-native food: "California Cuisine", found at the West Village **Batons**, which the *New York Times* recommended for its *"crisply browned potato pancake crowned with dollops of crème fraîche and a diadem of three caviars."* A spot for the cafe appearing in *Interview* in 1987 is credited to David LaChapelle, demonstrating another novel trend in restaurant advertising: fully art directed editorial photography, cinematic in ambition. **Odeon**, with its Left Bank reference, likely began the trend (a 1984 ad photographed in the Paris Metro is pure Melville). But a 1985 advert for Tuscan cafe **Il Cantinori** took the concept the max, with credits not only to photographer Christopher Makos, but also credits for the model, the hat, the gown, the collage, hair and makeup. The address is buried also in the fine print- it's another "if you know, you know" concept (Il Cantinori would be the setting for Carrie Bradsaw's ill fated 35th birthday and remains open to this day).

Set against these lushly art directed new-romantic photo shoots, a fresh conceptual-minimalism was inevitable. A restaurant called **Restaurant** went about as far as it could go. Full page ads in both *Details* and *Interview* simply listed a phone number, and the observation that "the world is expensive". Other ads revealed hours of opening (7pm - 3am), another laconically mentioned "no credit cards". The address is never listed (it was at 63 Carmine, today it is **JaJaJa Mexicana**). A visit by New York times critic Joseph Giovannini in October 1986 noted that it was unmarked on the street, but findable for an electric-blue Yves Klein painting in the window, Once inside, *"models and photographers and graphic artists and more models and more photographers. Waiters who were probably designers were serving people who were possibly waiters, and no could tell the difference, or care."* I like to picture it something like the spastic closing scene of Robert Altman's 1987 *Beyond Therapy*, with Jeff Goldblum playing all parts.

Gradually, in the 1990s, New York restaurant ads began to evaporate from the pages of *Interview*, *Details*, and *Paper*. All three titles were thriving, and their distribution becoming more national than local, and so the ads also became more general, and over time, blandly corporate. The subversive culture of downtown was slowly going mainstream, even as AIDS cruelly took the lives of so many of the creatives who had forged it. Though the total revolution of social media was still far on the horizon, computers, digital design, and on-demand food delivery were already revealing early clues of an upcoming transformation in how food be presented and consumed in New York. As early as 1986, **Cafe Sphinx** embraced Susan Kare's bitmapped "Cairo" typeface (shipped on the original Apple Macintosh); by 1998 ads might include a website address, albeit chunkily presented in formats such as "HTTP://www.QPR.com/**SAKURA**".

Food and parties are among the most ephemeral of human cultural endeavors; New York has of course excelled at both. Flip through these ads to learn about how it was done in the 1980s and 1990s, and how maybe it can be done again in the future.

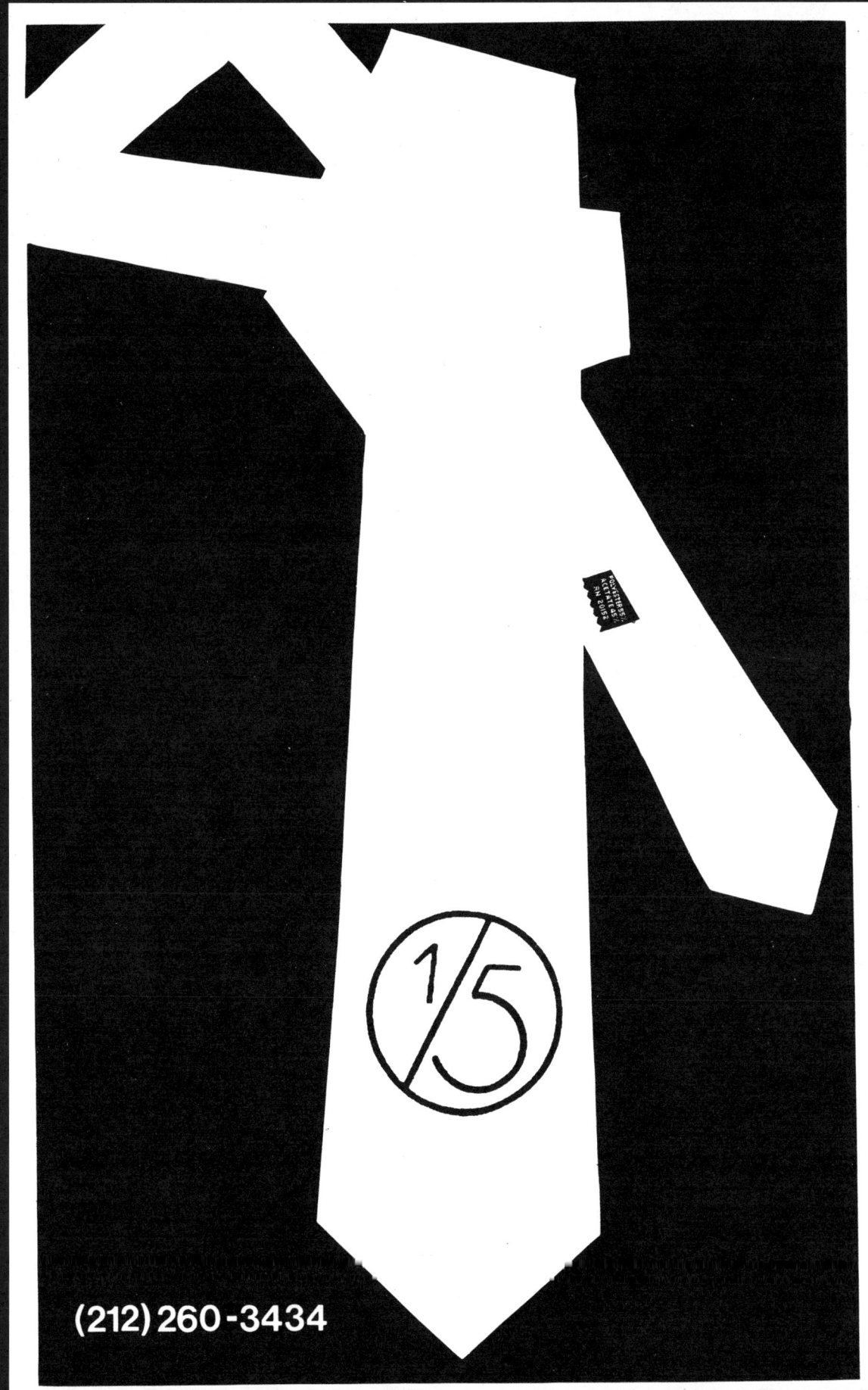

Yaffa Cafe

Open all nite

97 St. Marks Place
212-674-9302
212-677-9001

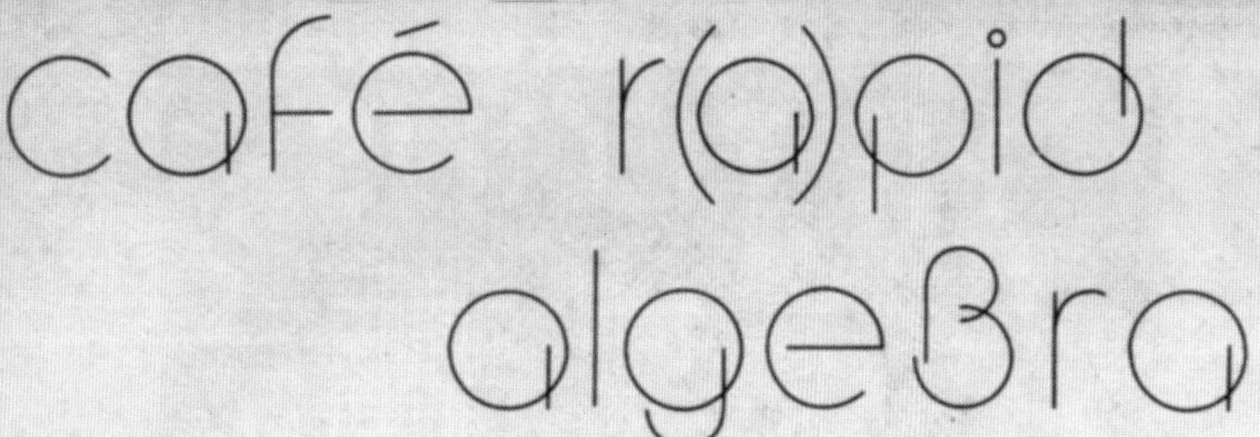

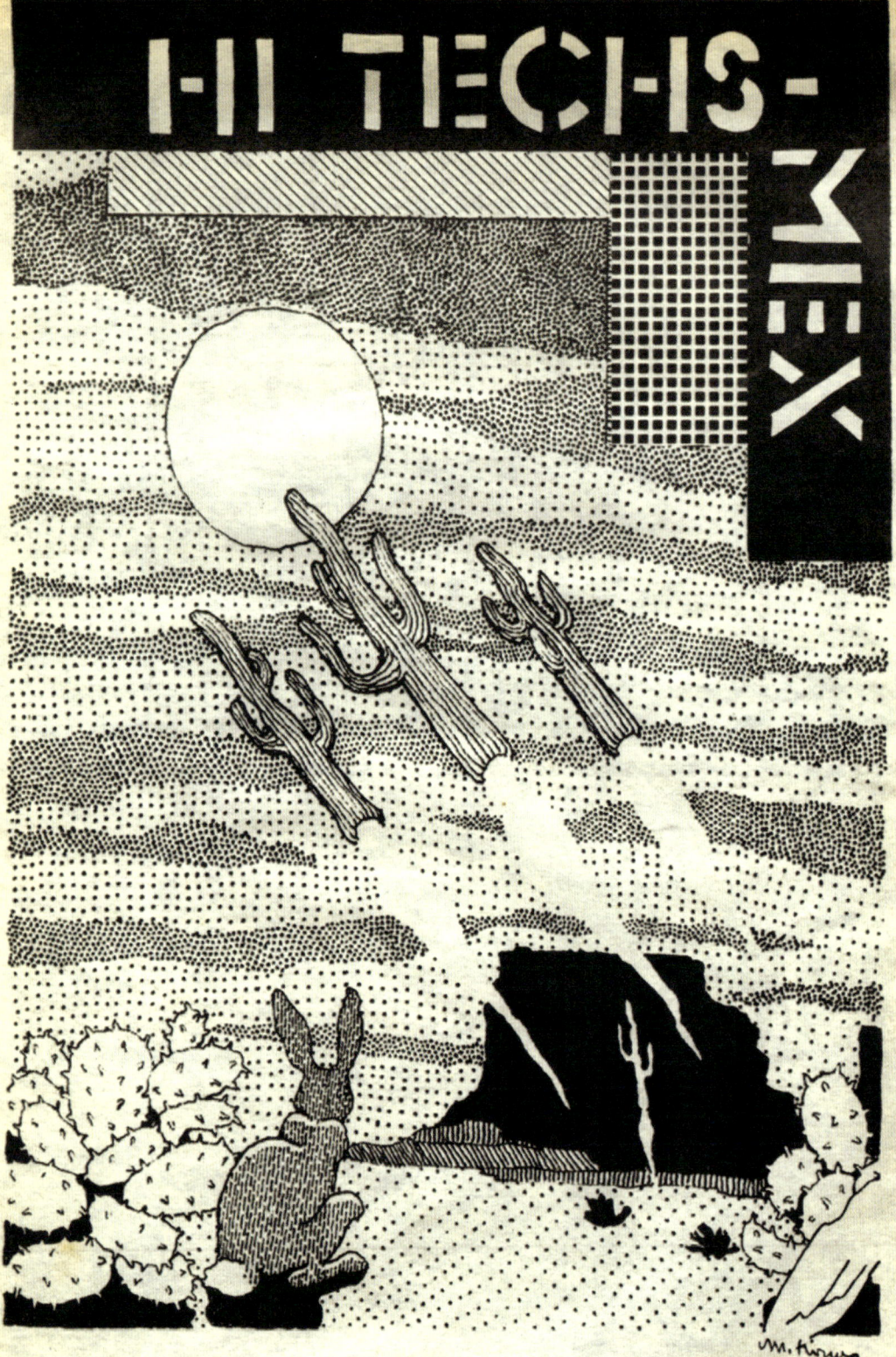

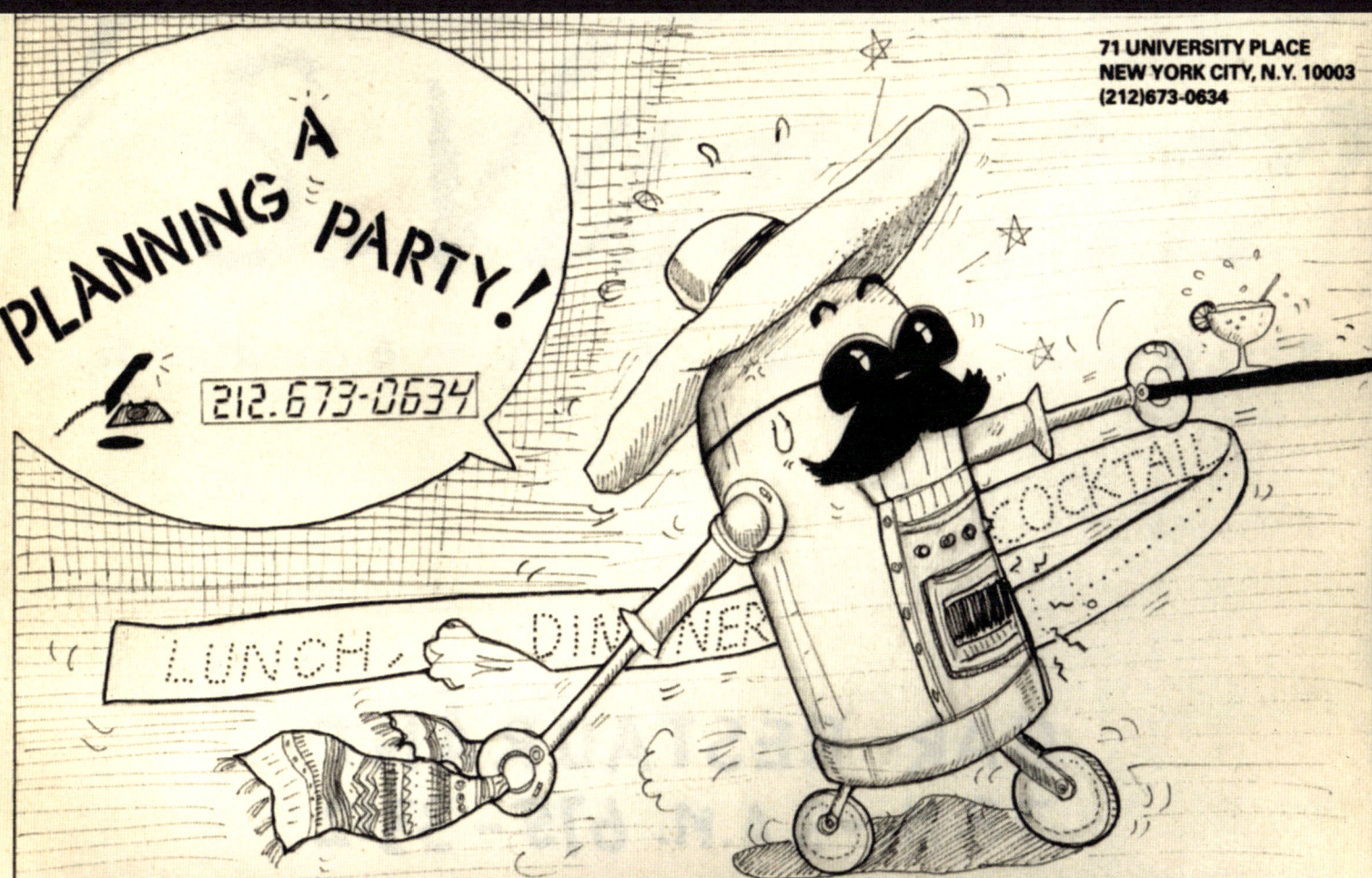

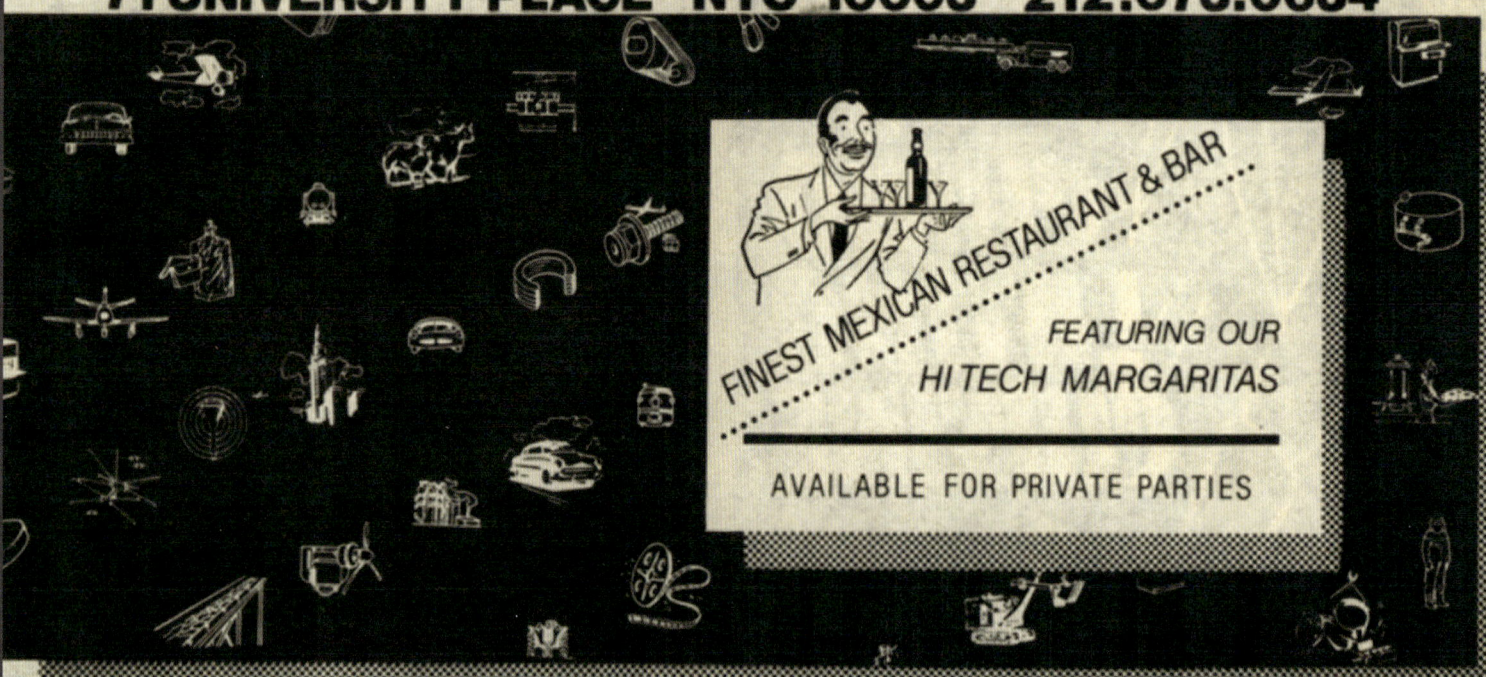

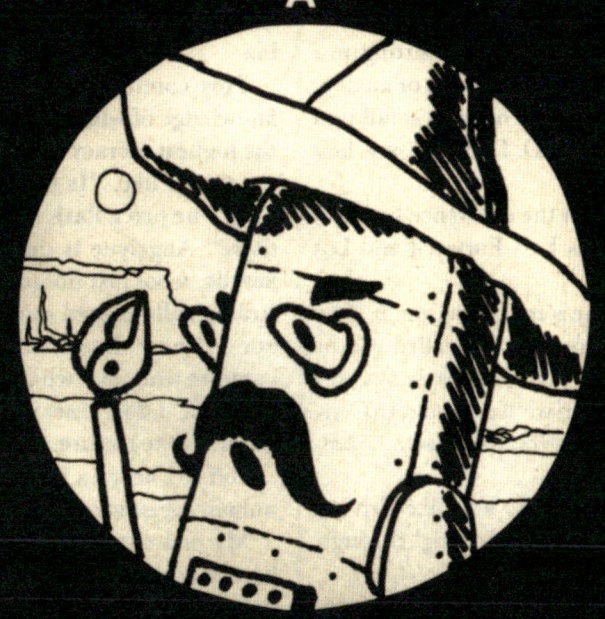

Seryna

S E R Y N A
520 MADISON AVENUE
NEW YORK CITY
RESERVATIONS
212 · 980 · 9393

Etherial Japanese Cuisine- Effervescent Champagne- Enchanting Ambience

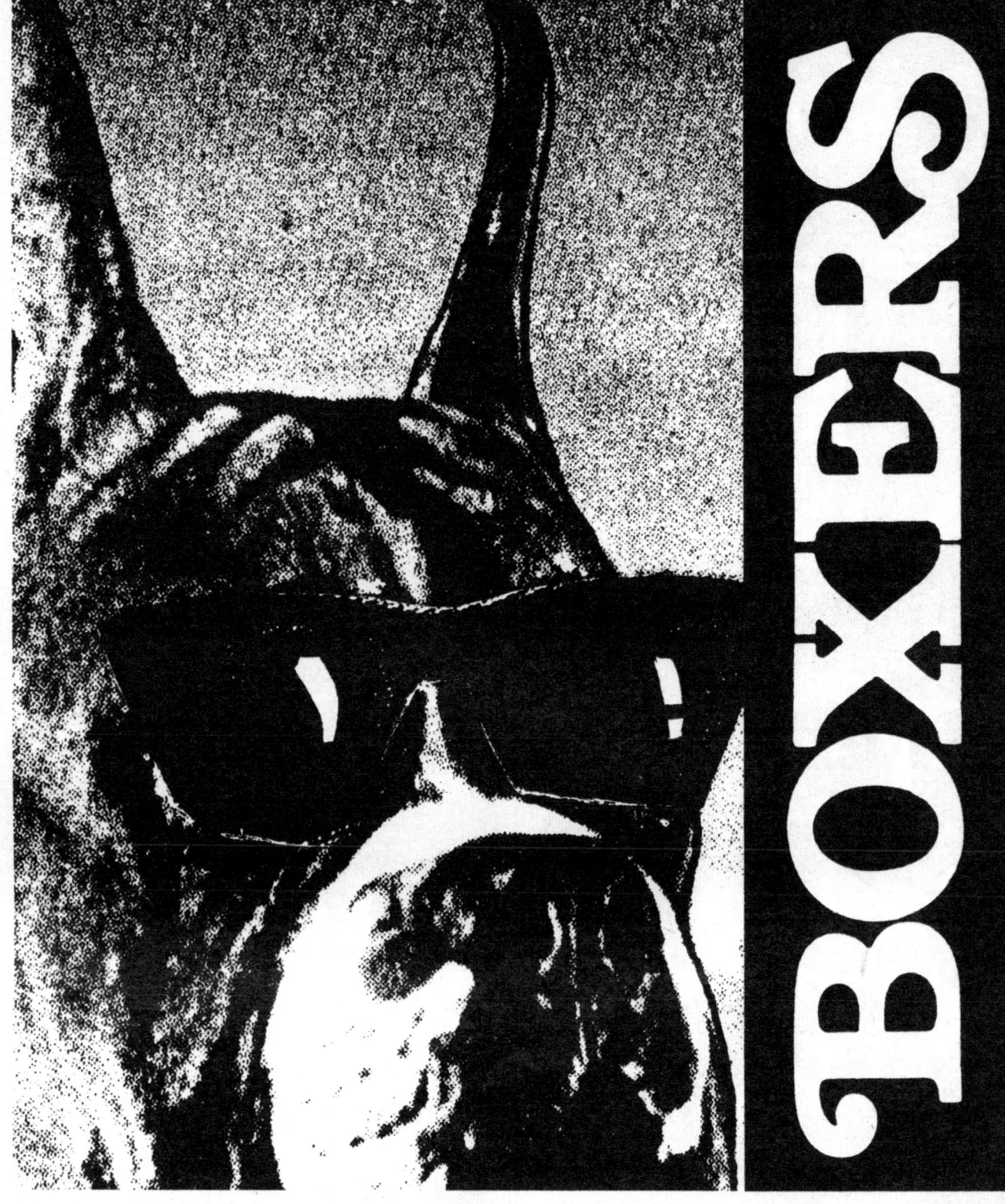

oysters

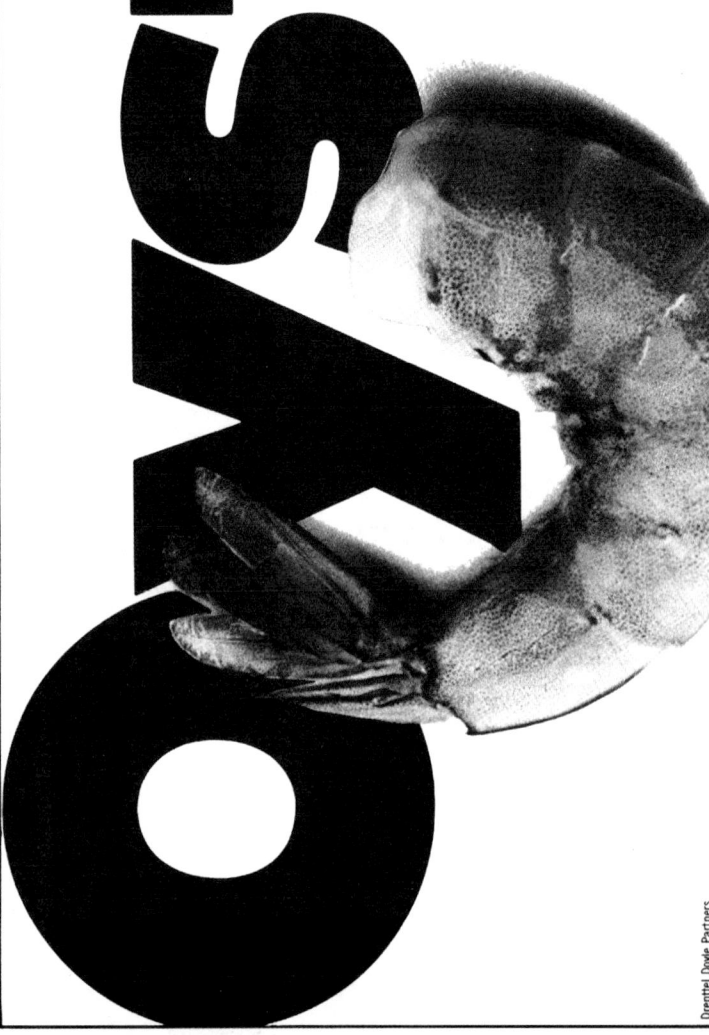

Fresh and squishy.
Oysters on a bed of ice
topped with a tasty
shallot and vinegar puree.
Dinnertime? Go fish!

CAROLINES*
At the Seaport

Restaurant
& Outdoor Café
Pier 17
233•4900

Drenttel Doyle Partners

shrimp

Sweet or sassy. Gently grilled, lightly fried or in a spicy cocktail. Lunchtime? Go fish!

CAROLINES
At the Seaport

Restaurant
& Outdoor Café
Pier 17
233·4900

87 E FOURTH ST NEW YORK 254-2550

Restaurant

EVELYNE'S

87 E FOURTH ST NEW YORK 254-2550

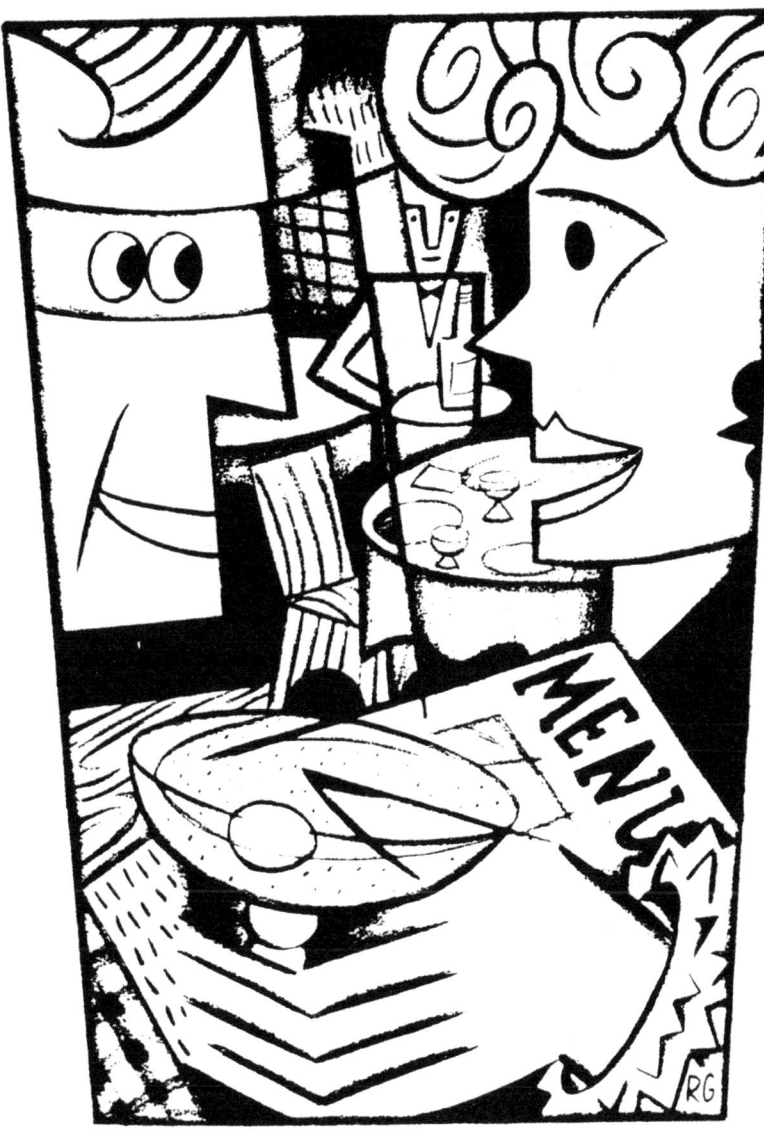

Restaurant

EVELYNE'S

200 WEST 70TH STREET • NEW YORK CITY • TELEPHONE 873-7411

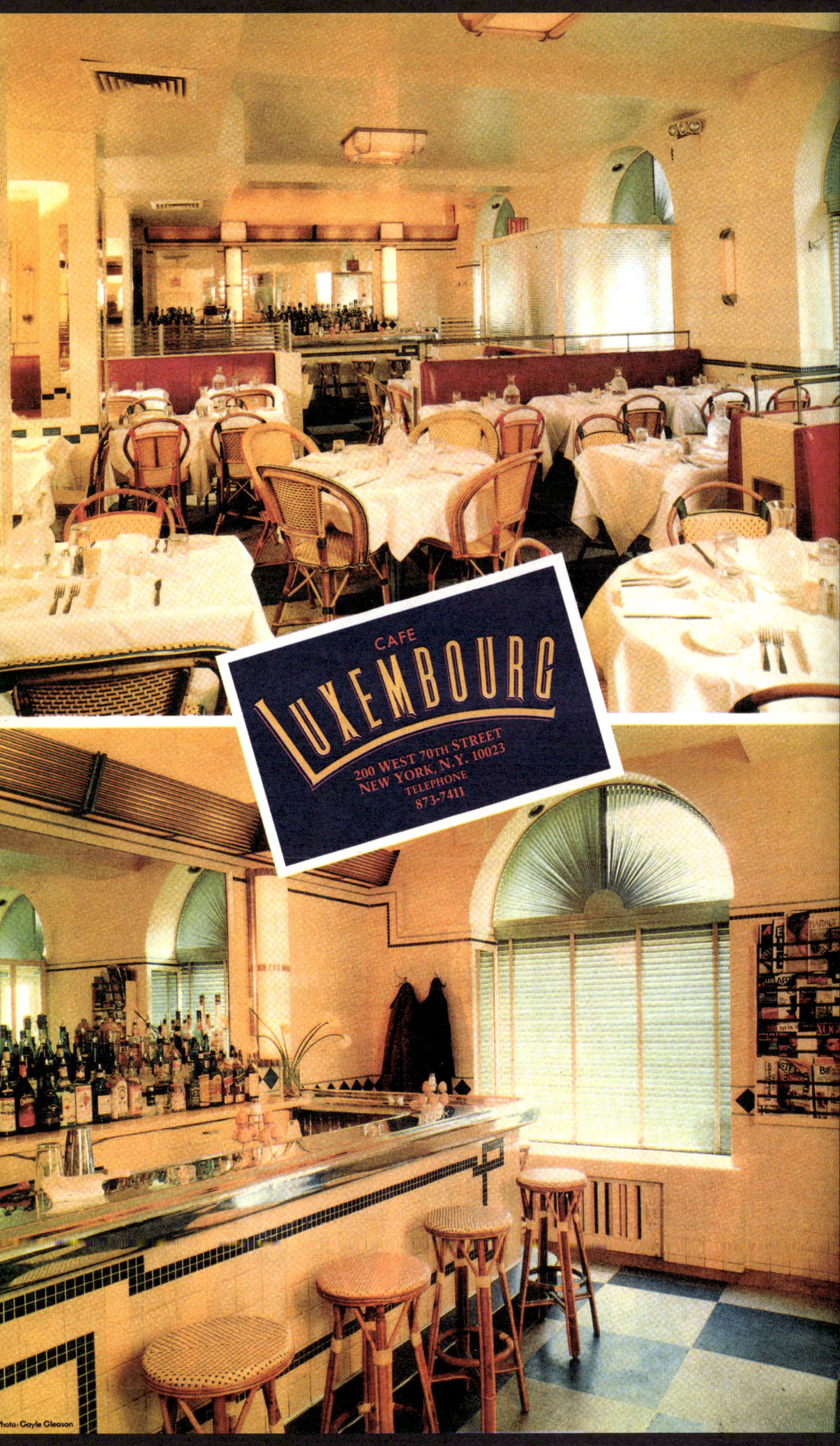

Lunch
Monday–Friday 12–2:30

Dinner
Monday–Saturday 6–11:30

158 Eighth Avenue
At Eighteenth Street
New York City 10011

Res. 212.741.2455

FRENCH RESTAURANT

LUNCH – DINNER

FIFTY-EIGHT EAST SIXTY-FIFTH STREET,
NEW YORK CITY 10021 (212) 794-9292

Bill Sharp

The Only Dancing Deco Diner

Complimentary Admission
With this Ad
GOOD THRU THE SUMMER

Open Wednesday, Friday, Saturday
Evenings 9pm-4am

641 West 51st & 12th Avenue
New York, N.Y. (212) 307-0030

Babette's

PHOTO DAVE ROSTEN

RESTAURANT/BAR
322 E 14 ST (BETWEEN 1ST + 2ND)
212/473-9834

SPECIALIZING IN
INTERNATIONAL PEASANT CUISINE

DINNER: 6-MIDNIGHT
DRINKS + SNACKS: 5-CLOSING
SUNDAY BRUNCH: NOON-4

CLOSED MONDAYS

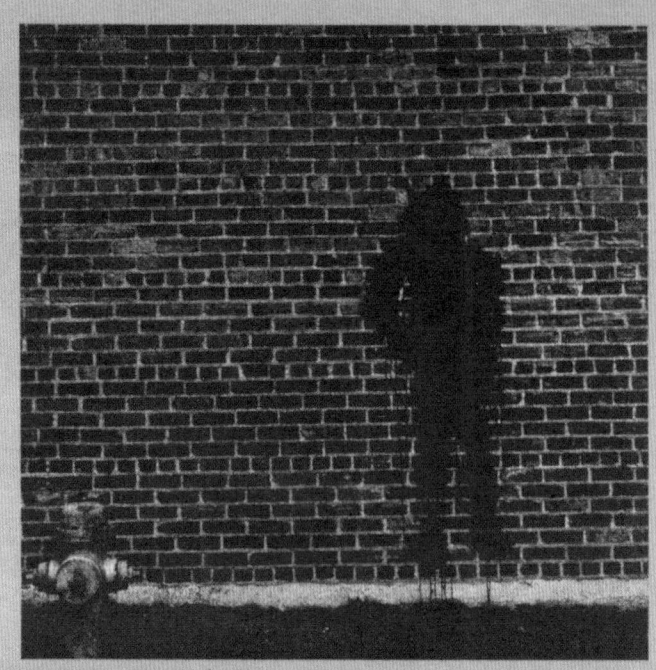
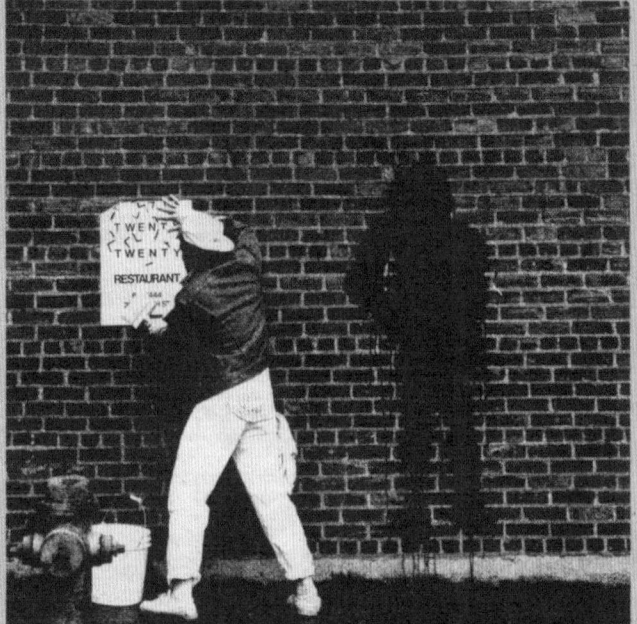
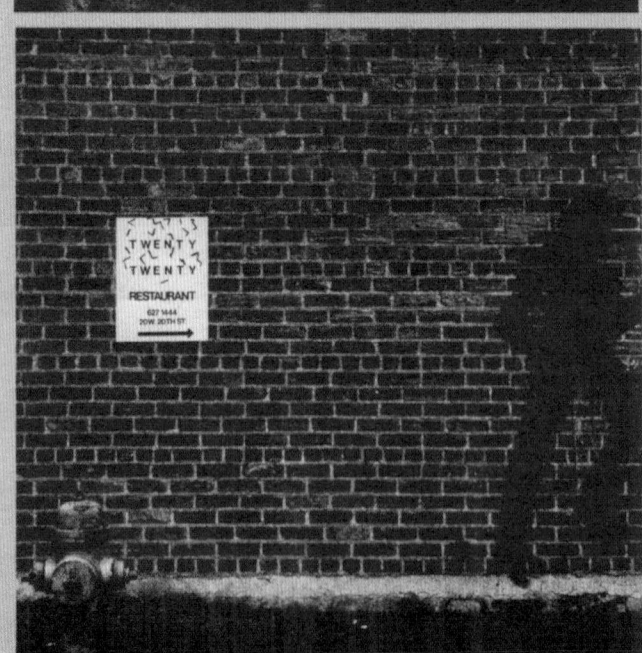

design by alexander brebner alexander brebner brer

thirty saint mark's place new york, new york 10003 dinner and late night supper **katsuhiko hasegawa, hana-ita**

BURGER CAFE

HAMBURGER HARRY'S

Charcoal and Mesquite Grilled
Beer and Wine
Friday and Saturday to 1 AM

"May well be the best (hamburger) in New York City."
NY Times 3.30.84

157 CHAMBERS STREET, NEW YORK, N.Y. 267-4446

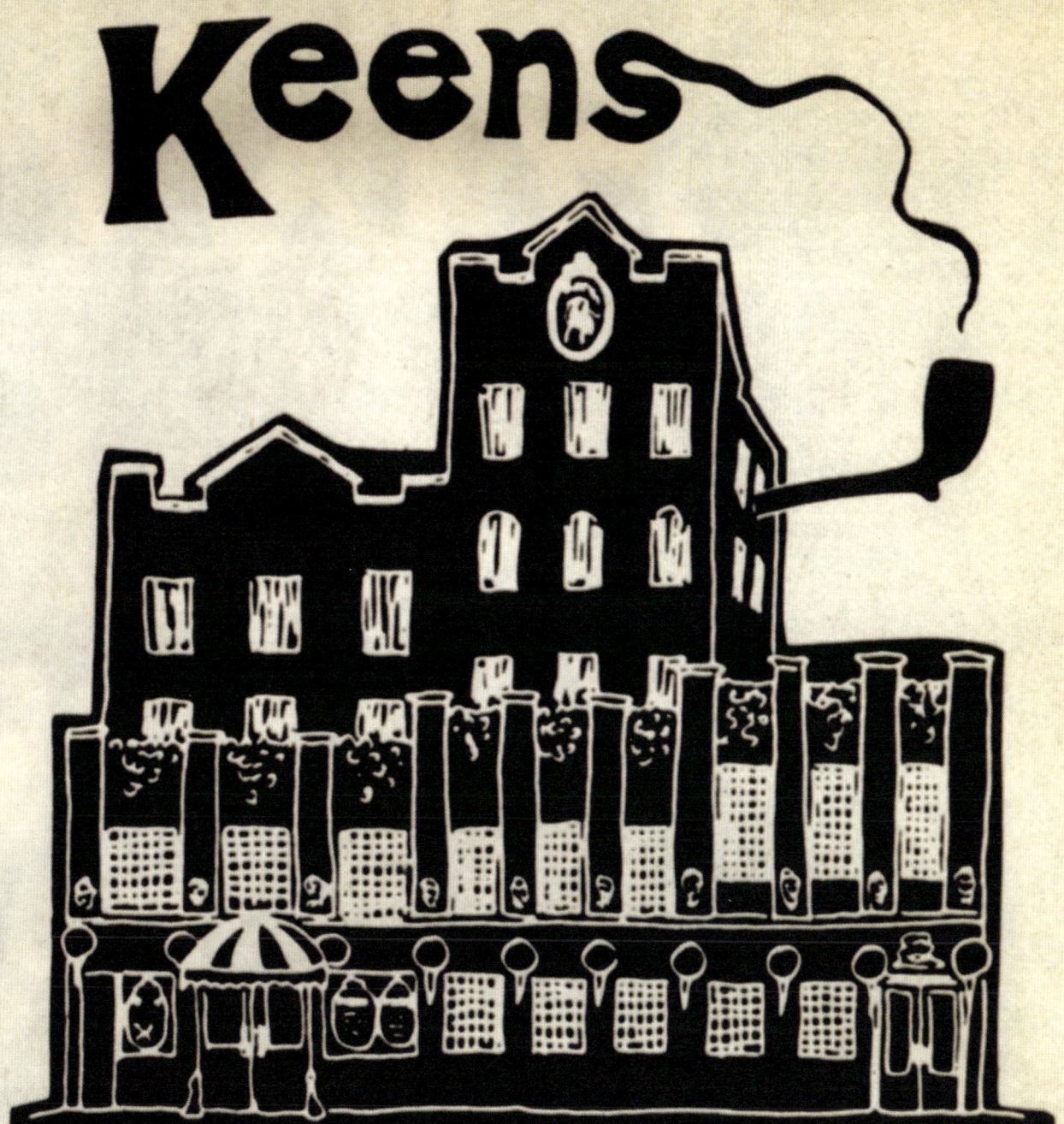

BAR RESTAURANT

A Place to Pasta Your Time Away
Lunch, Dinner, Supper, Seven Days a Week
Specializing in Private Parties
105 Hudson Street (CORNER OF FRANKLIN) 219-8802

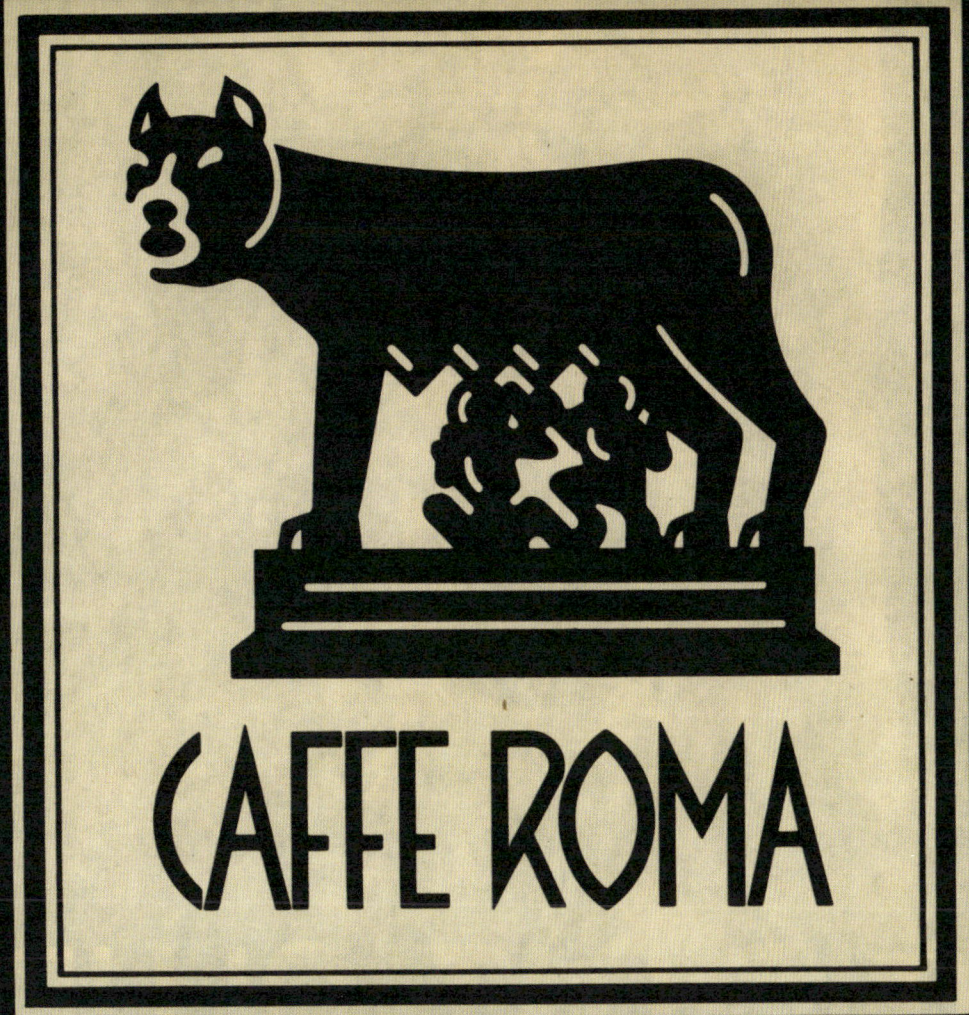

THE ONLY PERSON WHO DOESN'T NEED A RESERVATION.

(Well maybe, he's not Italian.)

Advertising Agency: Kirshenbaum & Bond

Positano
250 Park Avenue South
N.Y.C.
212-777-6211

Finally an authentic
Italian Restaurant
that doesn't have:
Red vinyl booths.
An embossed picture of
the Last Supper.
Waiters who
wear pinkie rings.
A signed photo
of Frankie
in the window.
Anything parmigiana.

Positano
250 Park Avenue South
N.Y.C.
212-777-6211

Advertising Agency: Kirshenbaum & Bond
Illustration: Everett Peck

CAFÉ *Batons* RESTAURANT

OPEN SEVEN NIGHTS — SUNDAY BRUNCH
62 WEST 11TH STREET NEW YORK, NY 10011 (212) 254·2288

ODÉON

PHOTO: GIANFRANCO GORGONI

233-0507

ODEON

2 3 3 0 5 0 7

THE ODEON

145 W. BROADWAY
IN TRIBECA SINCE 1980
212-233-0507

LUNCH • DINNER
WEEKEND BRUNCH

AFTER MIDNIGHT.

LIVE MUSIC
ODEON
233 0507

MONDAY TUESDAY WEDNESDAY

**Introducing Our
Elegant Private
Party Room**

*For Special Occasions
10 — 200 People*

Piano Nightly • Major Cards

GARVIN'S
More Than A Great Restaurant
19 Waverly Place 473-5261
Bet. B'way and 5th Ave.

CHAPITEAU
Restaurant

105 West 13th Street, New York, NY 10014 (At Sixth Avenue) • 212-929-8833

GRAND STREET
Restaurant & Bar

174 Grand Street (212) 941-6511

RESTAURANT *du jour*

KEY CAFE

Reservations 255-4655

Provence

38 MacDougal Corner of Prince at Sixth Avenue Telephone 475 • 7500 Closed Monday

CENTRAL FALLS

478 WEST BROADWAY NYC 212.475.3333

THE BEST RECEPTION IN TOWN

Century café

132 WEST FORTY-THIRD STREET, NEW YORK, NY 10036
212 398-1988

Lunch from 11:30 am. Dinner til 2:00 am. Bar open til 4:00 am.

NISHI NOHO NEWS

380 LAFAYETTE STREET NEW YORK CITY N.Y. 10003 212 677-8401

The Sunday brunches at NISHI NOHO have gotten off to a great start. Everyone raved about the new brunch menu and loved seeing our special fashion show presentations. Each Sunday we will present a new designer showing sensational creations while you enjoy your delicious brunch. The first Sunday we had a beautiful wedding kimono show and then we were lucky enough to see the suede and leather fashions of ROBERTO CAVALLI presented by RANY HIRSCH of the NEW YORK FASHION CLUB. In a spectacular suite at the PLAZA HOTEL the NEW YORK FASHION CLUB is a shopping experience unlike any other. Furs, knits, evening gowns and of course the CAVALLI fashions are shown in an ambiance of total luxury. In October we will have a wonderful treat for you every Sunday at NISHI NOHO. Call 677-8401 for reservations.

SAKE, the national drink of Japan, was first brewed thousands of years ago as an offering to the gods. In the beginning young virgins would chew the rice and then spit it into a large vessel where it would ferment and turn into sake. Things have changed since then and today's methods are as varied and complicated as the making of fine wine or beer. Now there are many different brands of sake and each has its own personality. At NISHI NOHO we serve SHO CHIKU BAI, America's number one selling sake, a dry and well balanced brew, loved by connoisseurs. One of our most popular cocktails, the "TOKYO ROSE" is made with cold sake and a touch of crème de cassis. OISHII!

Busy TREAT WILLIAMS stopped by before leaving for Paris to star in NATALIE DELON'S "SWEET LIES" with JOANNA PAKULA. After that TREAT heads to India to make STEVEN FREAR'S "THE DECEIVERS. A hectic year for one of our favorite actors!

NEIGHBORS: We want to give a special welcome to the ACME BAR AND GRILL and many thanks for brightening up Great Jones Street!

It's fun to be so close to the glorious PUBLIC THEATER. Handsome KEVIN KLINE thrilled many hearts as he dined almost nightly during his run of "HAMLET". Now he's in Africa filming with SIR RICHARD ATTENBOROUGH. BURT YOUNG and ROBERT DE NIRO came in from "CUBA AND HIS TEDDY BEAR" and the cast of "VIENNA LUSTHAUS" became wonderful friends. We hope their plans for a return engagement will come true. We look forward to the many productions in work for the new season.

HELP WANTED: We need more designers for our Sunday Brunch fashion shows so if you would like a showcase for your creations please contact us. We also need models. If you would like to volunteer a few hours on Sundays, you just might be discovered!

SIMON SAYS: PAUL SIMON may be partial to rosemary, sage and thyme but SUSHI is his favorite food. In ancient times the Japanese preserved fish by coating it with vinegared rice. From this humble beginning came our modern method of making sushi. A five year apprenticeship is required to become a Sushi Chef. No wonder they can turn the delicacies of the sea into such beautiful works of art. PAUL'S fabulous new album, "GRACELAND," is a long waited treat for everyone's ears. We are so lucky to have PAUL SIMON as one of our loyal friends.

The symbolic art form known as the NOH theater was perfected in Japan at least 400 years ago. In the spare setting of the NOH stage the mask is especially important. It provides the focal point for the audience and is central to the dramatic development of the play. In Japan today there are only seven or eight artists carrying on the tradition of NOH mask making. Each mask takes at least one month to make. These strange and beautiful objects are increasingly rare and of course of great value. An exhibition of these masks will be held at the URBAN ART RESEARCH CENTER, 500 Park Avenue at 59th Street, from the 7th of October to the 8th of November.

Summer is over and we look forward to an exciting Fall and Winter season. Our party facilities at NISHI NOHO are terrific so if you are planning a special event this winter, let us know. We can accommodate small or large groups and we would love to discuss your plans with you. We've already started booking holiday parties, so don't wait too long! Again, we want to thank all of you for being such good friends. We want NISHI NOHO to be one of your favourite spots so don't hesitate to tell us if you think we can do anything to make it a more enjoyable place for you.
See you next month!

NISHI NOHO NEWS

380 LAFAYETTE STREET NEW YORK CITY N.Y. 10003 212 677-8401

It's been an exciting month at NISHI NOHO! The SUNDAY FASHION BRUNCHES have been a great success. Everyone loved the menswear collection from MICHEL SAVOIA who has drawn rave reviews from all the fashion press for his bold approach to fine tailored men's suits, overcoats and sportswear. His clothes can be found at fine shops like L'UOMO, MADONNA and LOUTIE and buyers can contact his showroom at 68 Fifth Avenue by calling 929-6223. Another showstopper was the fabulous at home loungewear collection from JAMES BROOKENS of A REBOURS. These talented designers are a great addition to the world of fashion! The November brunches will feature:

NOVEMBER 2nd:

"RAGS" will present a collection of lace and leather and silk and leather fashions with leather hats, belts and accessories.

NOVEMBER 9th:

The annual fashion show designed and modeled by the members of the Japanese women's club "FRIENDS OF SHUFU-NO-TOMO N.Y.," sponsored by the Shufu-no-Tomo Publishing Co. Previous shows at the Plaza Hotel and Essex House were great successes.

NOVEMBER 16th:

In this age of mass produced fashion, the hand painted clothes by VALERIE LYNN really stand out. She will present a collection of holiday and resort wear painted with her latest designs. Her line is featured in over 300 boutiques and specialty stores nationwide.

NOVEMBER 23rd:

MADILYN SCOTT, better known as "MAD SCOTT" presents her distinctive couture fashion show. She has found a way to combine line and style to produce a collection of new designs that feels good, looks good and wears well. Her view of fashion is truly unique!

SATO TAKAKO'S RYUKYUAN DANCE COMPANY will make its American debut at THE ASIA SOCIETY, 725 Park Avenue, on the 21st and 22nd of November. Don't miss this wonderful group of dancers and musicians from Okinawa.

The gorgeous AYUMI ISHIIDA, one of Japan's most renowned actresses visited New York recently. AYUMI has won the Japanese equivalent of the Oscar many times and it is always a great treat to see her.

BROOKE SHIELDS, who has just finished shooting her new film, "BRENDA STARR," told us again how much she loved her twenty-first birthday party at NISHI NOHO. BROOKE is back at school but we can't wait to see the movie. And now some words of praise for the wonderful TERI SHIELDS who is one of the most terrific women anywhere. Everyone should have at least one loyal and true friend like her and BROOKE could never have grown into such an intelligent, warm and kind person without TERI's guidance. This beautiful new photograph of BROOKE is by super talented PATRICK DEMARCHELIER.

NISHI NOHO SUNDAY BRUNCH MENU
A COMPLIMENTARY BLOODY MARY
SALADS:
 SEAFOOD SALAD
 HAM & CHEESE
 CHICKEN SALAD
 ORIENTAL VEGETABLE
QUICHES:
 SPINACH AND MUSHROOM
 HAM
OMELETTES:
 ASPARAGUS
 ORIENTAL VEG.
 SPINACH, ETC.
NISHI NOODLE BOWLS
BEEF OR CHICKEN STEW
OUR FAMOUS DESSERTS
TEA COFFEE
COCKTAILS WINES SAKE BEER

We will be doing our Sunday Fashion shows throughout the Winter and Spring so we need more young designers who want a showcase for their clothes. Call Miss Saatchi at 677-8401 if you'd like to be put on our schedule. We need volunteer models too, so please call!

CONGRATULATIONS! Our great and dear friend GLEN ROVEN just won an EMMY award for outstanding musical direction and arranging for the 1986 TONY AWARD show. He also wrote and arranged the special musical material for the last EMMY SHOW for Alexander Cohen and NBC.

PARTY TIME! Now is the time to start planning a special event so call us at 677-8401. We can help you with a large or small party that you and your guests will love! See you next month!

RAUL JULIA had a wonderful surprise birthday dinner party for his beautiful wife MERLE a few days ago. We think RAUL is one of the most talented actors in the world and we love seeing him whenever he is in New York.

Bill Hong's
is back!
NEW LOCATION
227 East 56th Street
(between 2nd & 3rd Avenues)

We changed the address...
We enlarged the size...
But, we kept the quality!

Come in and enjoy
Chinese Food At Its Best.

(212) 355-2031

PIG HEAVEN

1540 2nd Avenue
Bet. 80th & 81st Streets
New York, N.Y. 10028

FOR PIG IN
Call (212) 744-4333

FOR PIG OUT
Call (212) 744-4887

For Be Bop Delivery call 982-0892

Ask about Be Bop Catering today!

Be Bop Cafe 28 West 8th Street

Ragu Lounge 176 MacDougal Street

PETER ALLEN MADONNA MATTHEW BRODERICK JOAN RIVERS MARVIN WORTH ALI McGRAW JAY McINERNEY RICHARD GERE DEBBIE HARRY MARLA HANSON CARRIE FISHER JODIE FOSTER DOMINICK DUNNE BROOKE SHIELDS DARRYL HALL JACKIE MASON JASON ADAMS ROY LICHTENSTEIN TOM BROKAW GENE SISKEL JIM DINE JENNIFER GREY MARY McFADDEN GAEL GREENE KEIKO REGINE DONNA RICE DIANNE BRILL CARL BERNSTEIN BEVERLY D'ANGELO MIMI SHERATON ANDREAS VOLLENWEIDER RICHARD BUTLER HORTON FOOTE LINDA ELLERBEE JOHN McENROE CAROLINA HERRERA HAROLD BECKER SYLVIA MILES CHARLES GRODIN SHERRY BLOOM ROBERT METZGER PARKIN SAUNDERS THOMAS McKNIGHT GARY KOTT BETSEY JOHNSON RONALDUS SHAMASK CALVIN TRILLIN HENRY GRETHEL ANGELO DIBIASE PETER NOVIELLO TONY BILL BIANCA JAGGER CARMEN D'ALESSIO PRINCESS TNT JOAN DIDION RAQUEL WELCH TERRI GARR MARY KAY PLACE CAROLA ROBIN WAGNER JODIE FOSTER PETER ALLEN MADONNA MATTHEW BRODERICK JOAN RIVERS MARVIN WORTH ALI McGRAW JAY McINERNEY RICHARD GERE DEBBIE HARRY MARLA HANSON CARRIE FISHER JODIE FOSTER DOMINICK DUNNE JOE DEITRICH MYKUL TRONN ANNIE LEIBOVITZ REX REED PETER ALLEN MADONNA MATTHEW BRODERICK JOAN RIVERS MARVIN WORTH ALI McGRAW JAY McINERNEY RICHARD GERE DEBBIE HARRY MARLA HANSON CARRIE FISHER JODIE FOSTER DOMINICK DUNNE BROOKE SHIELDS DARRYL HALL JACKIE MASON JASON ADAMS ROY LICHTENSTEIN TOM BROKAW GENE SISKEL JIM DINE JENNIFER GREY MARY McFADDEN GAEL GREENE KEIKO REGINE DONNA RICE DIANNE BRILL CARL BERNSTEIN BEVERLY D'ANGELO MIMI SHERATON ANDREAS VOLLENWEIDER RICHARD BUTLER HORTON FOOTE LINDA ELLERBEE JOHN McENROE CAROLINA HERRERA HAROLD BECKER SYLVIA MILES CHARLES GRODIN SHERRY BLOOM ROBERT METZGER PARKIN SAUNDERS THOMAS McKNIGHT GARY KOTT BETSEY JOHNSON RONALDUS SHAMASK CALVIN TRILLIN HENRY GRETHEL ANGELO DIBIASE PETER NOVIELLO TONY BILL BIANCA JAGGER CARMEN D'ALESSIO PRINCESS TNT JOAN DIDION RAQUEL WELCH TERRI GARR MARY KAY PLACE CAROLA ROBIN WAGNER JODIE FOSTER PETER ALLEN MADONNA MATTHEW BRODERICK JOAN RIVERS MARVIN WORTH ALI McGRAW JAY McINERNEY RICHARD GERE DEBBIE HARRY MARLA HANSON CARRIE FISHER JODIE FOSTER DOMINICK DUNNE MYKUL TRONN ANNIE LEIBOVITZ REX REED PETER ALLEN MADONNA MATTHEW BRODERICK JOAN RIVERS MARVIN WORTH ALI McGRAW JAY McINERNEY RICHARD GERE **48 BARROW. 691-6800** FISHER JODIE FOSTER DOMINICK DUNNE BROOKE SHIELDS DARRYL HALL JACKIE MASON JASON ADAMS ROY LICHTENSTEIN TOM BROKAW GENE SISKEL JIM DINE JENNIFER GREY MARY **DINNER SEVEN NIGHTS**

MELROSE NEW YORK

YOU TOO WILL FALL FOR THE GREAT FOOD AT THE MOONDANCE

OPEN 24 HOURS ON WEEKENDS

8:30 AM TO MIDNIGHT WEEKDAYS. WE SERVE BEER AND WINE. 80 6TH AVENUE AT GRAND STREET 226-1191 OUTDOOR CAFE

COZY-INN AT THE *Moondance*

OPEN 24 HOURS ON WEEKENDS

8:30 AM TO MIDNIGHT WEEKDAYS. WE SERVE BEER AND WINE. 80 6TH AVENUE AT GRAND STREET 226-1191 OUTDOOR CAFE

POLAROID BY MICHAEL ROBERTS

MR CHOW **344 N CAMDEN DR LA** **213 278 9911**

Portrait of Mr. Chow with his handmade watermarked Menu
by HELMUT NEWTON, Bel Air 1986
© 1986 Helmut Newton, Monte Carlo

Est. 1968
MR CHOW
151 Knightsbridge
London SW1X 7PA
England
Cable: CHOWCIAO
☎ 01-589-7347

MR CHOW LA
344 N. Camden Dr.
Beverly Hills, CA 90210
☎ (213) 278-9911 USA

MR CHOW
324 East 57th Street
New York, NY 10022
☎ (212) 751-9030 USA

MR CHOW
Rokkaku-Sagaru
Karasuma-Dori
Nakagyo-Ku
Kyoto, Japan
Opening Spring 1987

PORTRAITCALENDARJANUARYDECEMBER

DAN FLAVIN "POUR MME CHOW IN L'ORANGERIE" INK ON PAPER 3/6/82 3"x5"

MAY 1989

一二三四五六日一二三四五六日一二三四五六日一二三四五六日一二三
1 2 3 4 5 6 7 8 9 10 11 12 13 14 15 16 17 18 19 20 21 22 23 24 25 26 27 28 29 30 31
MRCHOWLONDONNEWYORKBEVERLYHILLSKYOTO
01589865621275190302132789911072 6732776

PORTRAITCALENDARJANUARYDECEMBER

ANDY WARHOL, "PORTRAIT OF MICHAEL CHOW," 1981. ACRYLIC AND SILKSCREEN ON CANVAS, ACRYLIC AND SILKSCREEN ON CANVAS WITH DIAMOND DUST. 40" × 40" EACH. COPYRIGHT © 1989 THE ESTATE AND FOUNDATION OF ANDY WARHOL.

APRIL 1989

六 日 一 二 三 四 五 六 日 一 二 三 四 五 六 日 一 二 三 四 五 六 日 一 二 三 四 五 六 日
1 2 3 4 5 6 7 8 9 10 11 12 13 14 15 16 17 18 19 20 21 22 23 24 25 26 27 28 29 30
MRCHOWLONDONNEWYORKBEVERLYHILLSKYOTO
0 1 5 8 9 8 6 5 6 2 1 2 7 5 1 9 0 3 0 2 1 3 2 7 8 9 9 1 1 0 7 2 6 7 3 2 7 7 6

51

zutto
It's Japanese

BAR • RESTAURANT 77 HUDSON ST. N.Y.C. TRIBECA. RESERVATIONS CALL 233-3287

FUCK PINTEREST.

library180 IS HERE.

VISIT library180
A NEW REFERENCE LIBRARY OPEN TO THE PUBLIC
180 MAIDEN LANE, FLOOR 26, NEW YORK
1-320-LBRY-180 @library.180

ALGORITHM-FREE INSPIRATION.

library180 IS HERE.

VISIT library180
A NEW REFERENCE LIBRARY OPEN TO THE PUBLIC
180 MAIDEN LANE, FLOOR 26, NEW YORK
1-320-LBRY-180 @library.180

SICK OF SEEING THE SAME IRVING PENN STILL LIFES ON EVERY MOODBOARD?

library180 IS HERE.

VISIT library180
A NEW REFERENCE LIBRARY OPEN TO THE PUBLIC
180 MAIDEN LANE, FLOOR 26, NEW YORK
1-320-LBRY-180 @library.180

HAVING A "SAVED" FOLDER ON INSTAGRAM DOES NOT AN ART DIRECTOR MAKE.

library180 IS HERE.

VISIT library180
A NEW REFERENCE LIBRARY OPEN TO THE PUBLIC
180 MAIDEN LANE, FLOOR 26, NEW YORK
1-320-LBRY-180 @library.180

PHOTO : JOHN KISCH

What next.

MANHATTAN SOUTH
413 GREENWICH ST., AT HUBERT
RESERVATIONS: 219-2182
LUNCH, DINNER, JAZZ

TELEPHONE BAR & GRILL

RESTAURANT · BAR · LOUNGE

SUSHI OLYMPICS NEW YORK '84

KAMON JAPANESE RESTAURANT 302 COLUMBUS AVE NYC 362-4490

KAMON　　　　　**JAPANESE RESTAURANT**　　　　　**302 COLUMBUS AVE NYC**　　　　　**362-4490**

JUPITER
CAFE

228 WEST 10TH STREET NYC (212) 924-9292

TUESDAYS THRU SATURDAYS FROM 4:00 PM • SUNDAYS 11:30 AM - 7:30 PM • CLOSED MONDAYS

CALIENTE CAB CO. BURRITO BAR (FORMERLY EXTERMINATOR CHILI)
305 CHURCH ST. 2 BLOCKS BELOW CANAL AT WALKER 219-9200

CAFE SPHINX
428 LAFAYETTE ST
NEW YORK NY 10003
TEL 212·505 1728

CAFE SPHINX
428 LAFAYETTE ST NEW YORK NY 10003 TEL 505 1728

CAFE SPHINX

428 LAFAYETTE ST NEW YORK, NY 10003 TEL 505 1728

MODEL: ILISA PHOTO: DAH-LEN HAIR: CARINO

MODEL: DOROTHEE

DAH-LEN

CAFE SPHINX
428 LAFAYETTE ST NEW YORK, NY 10003 TEL 505 1728

212 989-5621　　44 Bedford Street, New York City

Universal Grill

Universal Harmony

34 Downing St. NYC • (212) 675-4499

JERRY'S 103 NOW OPEN FOR LUNCH

LUNCH 12 TO 3:30, **M-F** • **BRUNCH** 11 TO 4, SA-SU • **DINNER** 6 TILL MIDNITE, 7 NIGHTS • **LATE SUPPER** SU-TH MIDNITE-2, FR&SA TILL 4

JERRY'S 103, 103 2ND AVE (6 STREET) • RESERVATIONS 777-4120

PRE-THEATRE AT REGINE'S

Once you've sampled
Regine's new
Pre-Theatre Dinner
you'll be back
for many an encore.

An adventure in
elegance, at a delicious
$19.75 prix-fixe.

Six to eight.

REGINE'S®
502 PARK AVENUE, NEW YORK, N.Y. (212) 826-0990

MODERN FOOD

MODERN FOOD CATERING

821 SECOND AVE NYC

212 UN7 6479

103 SECOND

533/0769

OPEN 24 HRS.

HAPPY HOURS: MON.-FRI., 4-7

OPEN 24 HOURS — 533/0769

PHOTO: JACK CARROLL

PHOTO: JACK CARROLL

103 SECOND RESTAURANT 2ND AVENUE AND 6TH STREET OPEN 24 HRS. 7 DAYS 533-0769

PHOTO: JACK CARROLL

103 SECOND RESTAURANT 2ND AVENUE AND 6TH STREET OPEN 24 HRS. 7 DAYS 533-0769

the world is expensive

675 - 3312
RESTAURANT

the world means business

BAR RESTAURANT
7 P.M. - 3 A.M. 675-3312

We accept foodstamps

RESTAURANT
675-3312 7PM - 3AM
but no credit cards

the world is a dish

RESTAURANT
7PM–3AM 675-3312

Sonia
BRASSERIE 1564 2ND AVENUE 212·535·7760

Les Tuileries

LES TUILERIES RESTAURANT
7 DAYS· NOON TO MIDNIGHT · SAT/SUN BRUNCH
40 CENTRAL PARK SOUTH NEW YORK 10019 212·832·3835

Les Tuileries
RESTAURANT

SIDEWALK CAFE · PIANO BAR
OPEN 7 DAYS, 12 P.M.–1 A.M.
BRUNCH, SATURDAY AND SUNDAY
40 CENTRAL PARK SOUTH
832-3833

CHEF STEFANE LAGORCE ·· GUIDE MICHELIN

La Côte Basque

Jean-Jacques Rachou salutes Pierre Franey

5 EAST 55th STREET, N.Y. 212-688-6525

SPEED LIMIT 55

154 W 26 ST. N.Y.N.Y. 10001 (212) 645-8476

HIGH-TECH
JAPANESE &
CONTINENTAL
CUISINE

MERIKEN

Lunch Monday–Friday 12–3 PM
Dinner Monday–Saturday 6–12 AM
Sunday 5:00–11 PM
Reservations 212-620-9684 American Express

189 SEVENTH AVENUE (at 21st ST) NEW YORK, NY 10011

the best kept secret in soho

patric

150 Varick at Vandam 691-5550 lunch m-f 12-2:30 • dinner m-sat 5:30-11• bar until 2am

Scaramouche
Bistro

157 Duane St. NYCity 964-2206

CAFE SPIGA/1022 THIRD AVENUE (60-61st) NYC 10022 212 223 1022

CAFE SPIGA/1022 THIRD AVENUE (60-61st) NYC 10022 212 223 1022

ELEPHANT & CASTLE
68 GREENWICH AVENUE NYC 243-1400

I LOVE OMELETTES
I LOVE OMELETTES
I LOVE OMELETTES
I LOVE OMELETTES
I LOVE OMELETTES
I LOVE OMELETTES
I LOVE OMELETTES
I LOVE OMELETTES
I LOVE OMELETTES

ELEPHANT & CASTLE
183 PRINCE STREET NYC 260-3600

teddy's

MAVERICK MEXICAN CUISINE
LUNCH DINNER LATENIGHT
219 WEST BROADWAY BETWEEN FRANKLIN & WHITE TELEPHONE 941-7070

teddy's

MAVERICK MEXICAN CUISINE
LUNCH DINNER LATENIGHT
219 WEST BROADWAY BETWEEN FRANKLIN & WHITE TELEPHONE 941-7070

Photo: Albert Watson Model: Frank Kennedy

LA COLONNA
17 West 19th Street NYC
(212) 206-8660

Lunch—Dinner—Supper

MOSAICO

24 FIFTH AVENUE (AT 9TH ST.)
NEW YORK N.Y. 10011
(212) 529 · 5757
LUNCH BRUNCH DINNER

OMEN
Artful Japanese Cuisine

113 Thompson Street

(212) 925-8923

KYOTO
NEW YORK

Southwestern Fare • South of Houston

PARIS, TEXAS

SOUTHWESTERN BISTRO

CASUAL RESTAURANT • BAR

212·475·0101

478 West Broadway · New York, NY 10012

*creative cuisine
sophisticated ambiance*

Manhattan Market

Open **Lunch** Mon. - Fri. 12 noon - 3pm/**Brunch** Sat. - Sun. 12 noon - 3:30 pm
Open **Dinner** 7 days, 6 pm - 12 midnight

Reservations: 212 • 752 • 1400 1016 Second Ave. (bet. 53rd & 54th Sts.)

GORDON'S

Serving Lunch, Brunch and Dinner. Open seven days a week.

2 MacDougal at Prince Street and Sixth Avenue, New York, N.Y. 10012, Phone (212) 475-7500

THE BREAD SHOP CAFE

"The minute you enter this cozy bakery-restaurant seven blocks north of the World Trade Center, the pleasant smell of freshly baked pastry greets you, triggering your salivating mechanism, and there's not one thing you can do."
—*NEW YORK MAGAZINE*

157 DUANE STREET
964-0524

PHOTOGRAPHER *JOHN PILGREEN* MODELS *LAURIE DEBAISE, GARDNER BOGLE* JEWELRY *TOM FLYNN*

SUMMER FESTIVAL
18–23 JUNE
CAFE SEIYOKEN 18 WEST 18 STREET NEW YORK N.Y. (212) 620-9010
LUNCH: MONDAY THRU FRIDAY
DINNER: FRIDAY AND SATURDAY 6:00-1:00 A.M. MONDAY THRU THURSDAY 6:00-MIDNIGHT SUNDAY 5:00-11:00 P.M.

PHOTOGRAPHY PAUL DANTUONO ART DIRECTOR RICHARD KARNBACH MODEL MASAYA MATSUI HAIR AND MAKE-UP KEN ICHI OKOCHI FLOWERS MATSUO TOMITA HAND MODEL LYNN ROFER

"FESTIVAL OF FLOWERS"
MAY 7TH-13TH
CAFE SEIYOKEN 18 WEST 18 STREET NEW YORK N.Y. (212) 620-9010
LUNCH: MONDAY THRU FRIDAY
DINNER: FRIDAY AND SATURDAY 6:00-1:00 A.M. MONDAY THRU THURSDAY 6:00-MIDNIGHT SUNDAY 5:00-11:00 P.M.

Café Seiyoken
18 W. 18th St. New York, N.Y. 10011
(212) 620-9010

PERSONALS

TO BE SEEN...AND CUISINE

(212) 620-9010

WAIT NO LONGER

If your extreme selectivity leaves you lacking yet sincerely wanting that special dining experience, your waiting is over.

CAFE SEIYOKEN

DO YOU WANT TO HAVE A PARTY?

Call Joe Byrnes (212) 620-9010

BUSINESS

Attractive Young Businesswoman requires Gentleman Companion for business dinner at Cafe Seiyoken.

PO Box 18w18 NYC (212) 620-9010

AGAIN WE PASSED EACH OTHER

in Cafe Seiyoken. You were at the sushi bar with that delicious assortment of Japanese delights. You made my mouth water. Let's not pass each other again! Next time let's share the duck.

NEXT TIME

ATTRACTIVE

slender MOM, seeks DAD who works late almost every night, for wild and wonderful Saturday evening at Cafe Seiyoken. We'll wine and dine all night with no kids. To respond, just call for reservations, then come home early.

JUST CALL

I KNOW YOU'RE OUT THERE

Seeking special woman to share an intimate evening at my favorite restaurant, Cafe Seiyoken. I'm witty and you'll love the atmosphere. Here's hoping we toast sake cups together.

PO Box 18w18 NYC SPECIAL

ENJOY A TRIO?

How's about you, me and the sushi chef at Cafe Seiyoken. He'll prepare to suit your taste and mine. I know we'll like the same things. Don't hesitate, meet me at Seiyoken tonight.

DON'T HESITATE

LOOKING FOR A GREAT TIME?

(212) 620-9010

Café Seiyoken
18 W. 18th St.
New York, N.Y. 10011
(212) 620-9010

DINING AND... WHO KNOWS?

Attractive art deco setting seeks sophisticated, amusing, fashionable men and women for drinks, dining and...who knows? Interests include: fine cuisine, electric atmosphere and late hours. If this is you, too—Let's get together and have some fun. Call

FOR RESERVATIONS

CREATED BY C.R.A.C.

Cafe Tabac

232 E 9th Street • NYC 10003 • (212) 674-7072

Serving dinner Sun-Wed, 6pm-12am & Thurs-Sat, 6pm-1am

Barocco **PRODUZIONE** UN FILM DELLA **TOSCANA**

CUCINA-VISION

RISTORANTE E BAR ITALIANO

BAROCCO

301 CHURCH STREET NYC TELEFONO 212 431 1445
UNA TRATTORIA TOSCANA
DISTRIBUZIONE? BAROCCO TO GO TELEFONO 212 431 0065
CORPORATE CATERING & TAKE-OUT

Acute Cafe

110 West Broadway New York (212) 349-5566

CAFFÈ DELLA PACE

529-8024

48 east 7th street nyc

"Cafe Society"
43 East 20th Street
673-8885

Lunch: Weekdays
Dinner: Nightly*
Dancing: Weekends 12PM – 4AM

*Closed Sundays for Private Parties.

Greene Street

101 Greene Street (between Prince & Spring) 925-2415

"Cafe Society"
43 East 20th Street
673-8885

Where the elite meet...

Lunch: Weekdays
Dinner: Nightly
Dancing: Weekends 12PM – 4AM

Greene Street

ELEGANT DINING
IN SOHO
LIVE JAZZ NIGHTLY

101 Greene Street (Between Prince and Spring) 925-2415

SUSHI
SOUNDS
SPIRITS

Hayashi

JAPANESE RESTAURANT

Sun.-Thurs. 6 PM-2 AM
Fri.-Sat. 6 PM-3AM

145 BLEECKER ST., GREENWICH VILLAGE, N.Y.C. (212) 505-2366

The only real Cajun & Creole cookin' East of L.A....

THE RITZ CAFE

★ Star Indicates An Item That Is Very Spicy!

FIRST COURSES

★ Creole Gumbo cup	3.95
bowl	5.95
Ritz House Salad	3.50
Artichoke Rex	4.95
Oysters on the Half Shell	4.50
Shrimp Remoulade	5.95
Spring Onion Crab Cake with Green Tomato Relish	7.50
★ Freshwater Crawfish	5.95
Pickled Shrimp	5.95
Ritz Combination Shellfish Platter (all of the above)	14.95
Oysters Z'arbres	6.50

MAIN COURSES

Oysters Samantha ★ with Tasso & Pasta	12.50
Red Snapper Carolyn with Crab & Creole Cream Sauce	14.50
Creole Eggplant Stuffed with Shrimp & Crab	13.95
Filet of Smoked Beef with Crawfish Sauce	17.50
Three Smothered Quails with Dirty Rice	14.95
Drunken Shrimp ★ Cooked in Beer & Butter	14.95
Herb Blackened Lamb Chops with Roasted Garlic	16.95
Cajun Cassoulet with Duck, Andouille & Red Beans	11.95
Broiled Swordfish with Sweet Red Pepper Butter	15.95
Cajun Blacksteak ★ with Three Pepper Butter	17.95
Boneless Breast of Chicken, Cornbread & Oyster Dressing	10.50
Cajun Blackfish ★ Hot & Spicy	12.95
★ Crawfish Etouffée (Smothered Louisiana Crawfish)	16.50

LUNCH SPECIALS
Served until 4:00 P.M.

New Orleans Oyster Loaf with Creole Potato Salad	8.50
Stacey's Hot Chicken Salad	7.95
Crawfish Pirogue with Smoked Redfish Salad	9.50
Braised Veal Shank with Dirty Rice	10.75
Cajun Meatloaf with Tasso Gravy & Sweet Potatoes	7.95

DESSERTS

Chocolate-Rum Pecan Pie	3.95
New Orleans Bread Pudding, Bourbon Sauce	3.50
Warm Berry Compote, Cognac Ice Cream	4.50
Creole Cream Cheese Pecan Pie	3.75
Jack Daniels Chocolate Ice Cream with Pecan Diamonds	3.95
Cranberry-Orange Sorbet	3.50

NEW YORK — LOS ANGELES

LUNCH: MONDAY—FRIDAY
DINNER: MONDAY—SATURDAY
RESERVATIONS: (212) 684-2122

...Comes to New York on 32nd at Park

Starbucks
restaurant and club

STARBUCKS 151 East 45th Street New York City Tel. 697-5544

PROVECHOS

caribbean restaurant / bar

21 W. 17st. N.Y.C. 255-2408

TEXARKANA

Yasmine and
Tony Sanchez at
64 West 10th Street

Photography by Frijady Moogin

"The Russian Tea Room" by Otto Rothenburgh

The Russian Tea Room

150 West 57th Street New York 265-0947

124

Elaine's
Tonight!

For the Wine,
the Conversation,
the People....
and the Best Food
on this End of the Island.

1703 Second Avenue 534-8103 / 534-8114

JAPANESE CUISINE AND MORE...

HASAKi

210 EAST 9TH STREET ■ 212-473-3327 ■ 7 NIGHTS A WEEK ■ 5-MID

5-7 PM, Everyday　　　　$12.00　　　　　　　　AUTHENTIC FULL COURSE DINNER AND MORE...

Twilight Dinner

HASAKI

210 EAST 9TH STREET ■ 212-473-3327 ■ 7 NIGHTS A WEEK ■ 5-MID

M&Co.

open 24 hours

Restaurant FLORENT, 69 Gansevoort Street (in the meat market) 989-5779

AVENUE A SUSHI

ANNOUNCES
AN ORIGINAL T-SHIRT CONTEST
ENTER AND AMAZE YOUR FRIENDS!

T-SHIRT MUST SAY THE WORDS "AVENUE A" ; T-SHIRT MUST BE HAND MADE, ONE OF A KIND* IF ACCEPTED AS A FINALIST, CONTESTANT RECEIVES A 10.00 DINNER TICKET

ONE FIRST PRIZE - 200.00 DINNER TICKET
ONE SECOND PRIZE - 100.00 DINNER TICKET
ONE THIRD PRIZE - 50.00 DINNER TICKET
FIVE FOURTH PRIZES - 25.00 DINNER TICKET
TEN FIFTH PRIZES - 15.00 DINNER TICKET

T-shirts will be displayed on our walls. Prizes will be awarded at our annual anniversary party on June the 7th, 1993

Then the t-shirts will be auctioned off to benefit BLUE LIGHT, a non-profit organization which delivers free food + support to home bound people who have been infected with the HIV virus in the East Village.

DEADLINE FOR ALL SHIRT ENTRIES WILL BE
MAY 12

FOR MORE INFO CALL KUMIKO

AVE. A JAPANESE RESTAURANT 103 AVE. A NY, NY 10009 982-8109

NOSMO KING

BAR, RESTAURANT, JUICE BAR, CATERING
54 VARICK ST., N.Y.C. 10013, 212-966-1239
SERVING DINNER TUESDAY THROUGH SATURDAY

1/5

more than a fraction

(212) 260-3434

133

GOTHAM
Bar and Grill

12 EAST 12TH STREET, NEW YORK 10003, 212 620 4020
LUNCH, DINNER,
LATE SUPPER AND SUNDAY BRUNCH

THE KEY TO YOU HEALTH

THE FIRST ORIGINAL
CHINESE RESTAURANT
SERVING DISTINCTIVE
VEGETARIAN FOOD

144 W 4TH ST
(AT 6TH AVE)
260 • 7130

48 BOWERY
(AT CANAL)
571 • 1535

Francine presents
Thursday Salsa Happy Hour
at

Tatiana
RESTAURANT • BAR • LIVE MUSIC

photo: Terry Fugate-Wilcox

**Francine's
newest concept of drinking and dining
in SoHo**

Live jazz and blues • No cover charge
Appetizers on us • One free drink for ladies from 5-7pm
Available for large private parties
Art by Terry Fugate-Wilcox

**26 Wooster Street
reservations: 212.226.6651**

sounds

SOUNDS GREAT!
New York's D.J. &
Music/Video
Restaurant/Bar

Lunch, Brunch
Dinner & Late Supper
Till 1 AM
Thur-Sat 3 AM

71 University Place
At 10th Street
673-0634

HOGS & HEIFERS SALOON

BEER & SHOTS

COUNTRY & ROCK

859 WASHINGTON ST. NYC (212) 929-0655

Oh·Ho·So
Cantonese cuisine in casual elegance
395 West Broadway New York City
Reservations: 966-6110

SAKURA
Japanese Restaurant

さくら

615 1/2 Hudson St. N.Y. N.Y. 10014
(Between W.12th & Jane St.)
(212) 645-2128
HTTP://www.QPR.com/SAKURA

PARK BISTRO 414 PARK AVENUE SOUTH NY, NY 10016 212.689.1360

FUN
 FOOD
 FRENCH FRIENDLY

CAFE SEIYOKEN
18 West 18th Street

TEXARKANA
64 West 10th Street

BANDITO DITTO
33 Greenwich Avenue

CENTRAL FALLS
478 West Broadway

LE CIRQUE
58 East 65th Street

NISHI
325 Amsterdam Avenue

LES TUILERIES
40 Central Park South

OMEN
113 Thompson Street

CENTRAL FALLS
478 West Broadway

THE ODEON
145 West Broadway

Index

7A (1993), 128
103 Second Restaurant (1984), 74
103 Second Restaurant (1986), 75
103 Second Restaurant (1986), 76
103 Second Restaurant (1986), 77
Acute Cafe (1982), 110
Avenue A Sushi (1993), 130
Babette's (1986), 19
Bandito! (1986), 116
Bandito! (1986), 116
Bandito! (1986), 117
Bandito! (1986), 117
Bandito! (1986), 118
Bandito! (1986), 119
Bandito! (1986), 119
Barocco (1998), 109
Batons (1986), 28
Batons (1987), 29
Be Bop Cafe (1984), 44
Bill Hong's (1986), 42
Boxers (1992), 11
Cafe Americano (1985), 24
Caffè Della Pace (1993), 111
Cafe Luxembourg (1985), 17
Cafe Luxembourg (1986), 16
Cafe Luxembourg (1989), 16
Cafe Rapid Algebra (1985), 5
Cafe Seiyoken (1984), 104
Cafe Seiyoken (1984), 105
Cafe Seiyoken (1986), 106
Cafe Seiyoken (1986), 107
Cafe Society (1981), 112
Cafe Society (1981), 113
Cafe Sphinx (1986), 66
Cafe Sphinx (1986), 67
Cafe Sphinx (1986), 68
Cafe Sphinx (1986), 69
Cafe Tabac (1992), 108
Caffe Roma (1986), 25
Caliente Cab Co. (1990), 65
Caroline's (1987), 12
Caroline's (1987), 13
Central Falls (1985), 38
Century Cafe (1984), 39
Chapiteau (1986), 34
Chinese Chance (1983), 88
Dok Suni's (1998), 4
El Teddy's (1989), 96
El Teddy's (1990), 97
Elaine's (1984), 124
Elaine's (1984), 125
Elephant & Castle (1983), 94
Elephant & Castle (1984), 95
Evelyne's (1984), 14
Evelyne's (1985), 15
F Sharp (1982), 19
Flamingo East (1993), 60
Florent (1993), 129
Garvin's (1982), 34
Go (1984), 21
Gordon's (1981), 103
Gotham (1984), 134
Grand Street Restaurant & Bar (1993), 35
Greene Street (1981), 112
Greene Street (1982), 113
Hamburger Harry's (1984), 22
Hasaki (1986), 126
Hasaki (1986), 127
Hayashi (1985), 114
Hi Techs - Mex (1984), 6
Hi Techs - Mex (1986), 7
Hi Techs - Mex (1985), 8
Hi Techs - Mex (1986), 9
Hogs & Heifers (1994), 138

Il Cantinori (1985), 53
Indochine (1993), 3
Jerry's 103 (1991), 71
Jupiter Cafe (1986), 64
Kamon (1983), 62
Kamon (1984), 63
Kamon (1984), 63
Keens (1985), 23
Key Cafe (1986), 36
La Colonna (1984), 98
La Cote Basque (1985), 86
Le Cirque (1985), 18
Les Tuileries (1983), 84
Les Tuileries (1984), 85
Manhattan Market (1981), 102
Manhattan South (1985), 58-59
Melrose (1989), 45
Meriken (1984), 89
Modern Food (1985), 73
Moondance (1985), 46
Moondance (1986), 47
Mosaico (1989), 99
Mr Chow (1984), 48
Mr Chow (1986), 49
Mr Chow (1989), 50
Mr Chow (1987), 51
Nishi Noho (1985), 40
Nishi Noho (1986), 41
Nosmo King (1990), 131
Odeon (1984), 30
Odeon (1988), 31
Odeon (1998), 32
Odeon (1987), 33
Oh Ho So (1981), 139
Omen (1984), 100
One Fifth (1981), 1
One Fifth (1983), 132
One Fifth (1985), 133
Paris Texas (1990), 101
Park Bistro (1998), 141
Patric (1993), 90
Pig Heaven (1986), 43
Positano (1987), 26
Positano (1987), 27
Provechos (1985), 121
Provence (1986), 37
Regine's (1981), 72
Restaurant du Jour (1990), 35
Restaurant (1986), 78
Restaurant (1986), 79
Restaurant (1986), 80
Restaurant (1986), 81
Revolution (1986), 83
Roxanne's (1986), 18
Sakura (1998), 140
Scaramouche (1984), 91
Seryna (1985), 10
Sonia (1986), 82
Sound (1984), 137
Speed Limit 55 (1987), 87
Spiga (1989), 92 - 93
Starbucks (1981), 120
Tatiana (1991), 136
Telephone Bar & Grill (1998), 61
Texarkana (1982), 122
The Bread Shop (1981), 103
The Ritz Cafe (1986), 115
The Russian Tea Room (1990), 123
Twenty Twenty (1987), 20
Universal Grill (1993), 70
Universal Harmony (1993), 70
VP2 (1990), 135
Yaffa Cafe (1993), 2
Zutto (1993), 52

Nikki Igol
PUBLIC IMAGE LIBRARY: NYC Restaurant Ads 1981-1998

Published by Blurring Books
BlurringBooks.com
@BlurringBooksNYC

Introduction: Nelson Harst
Book Design: Stephen Smitty
Project Management: Sean M. Johnson

First Edition, First Printing

All rights reserved. No part of this publication may be reproduced in any form or by any electronic means without prior written permission from the copyright holders.

Library of Congress control number - 2025932392
ISBN - 978-1-963814-11-8
Printed in China